To Sylvia, Geoffrey Bles and Chaiya

Your legacy lives on

First published in Great Britain in 2018

Instant Apostle,
The Barn,
1 Watford House Lane,
Watford, Herts
WD17 1BJ

Other books by the author:
Time to Live: The Beginner's Guide to Saying Goodbye

British Library Cataloguing-in-Publication Data

A catalogue record for this book is available from the British Library

This book and all other Instant Apostle books are available from Instant Apostle:

Website: www.instantapostle.com
E-mail: info@instantapostle.com

Chaiya Art Awards
www.chaiyaartawards.co.uk
Registered charity: Chaiya Trust 1176237.

ISBN 978-1-909728-90-5

Printed in Great Britain

WHERE IS GOD IN OUR 21ST CENTURY WORLD?

ANN CLIFFORD

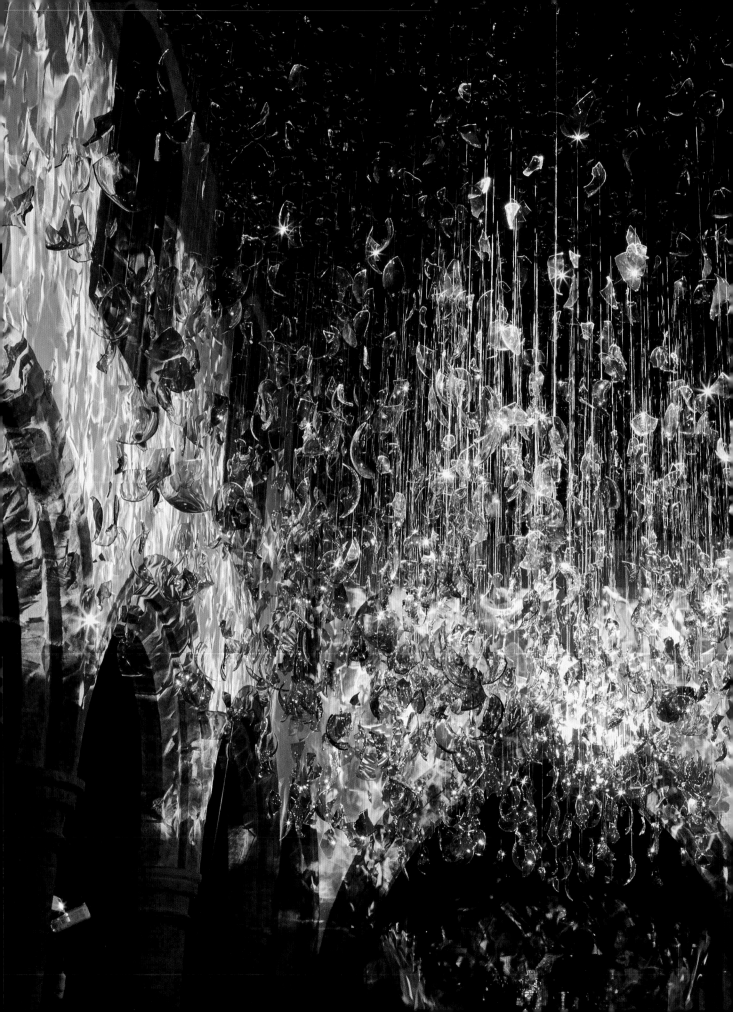

CONTENTS

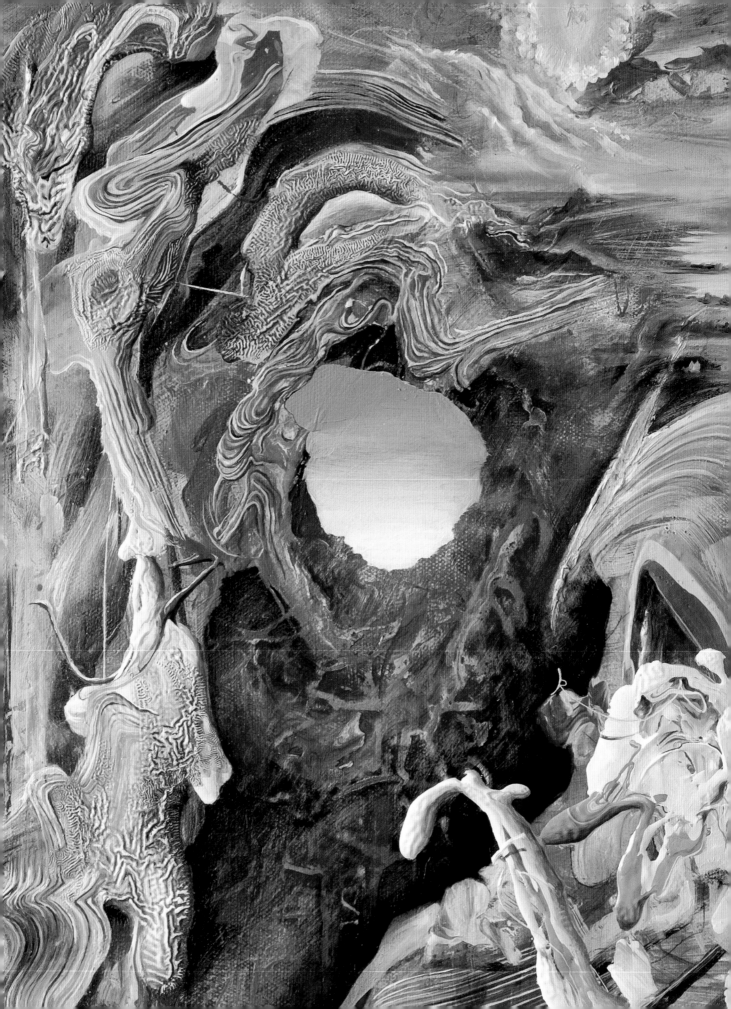

HISTORY
CHAIYA TRUST

Katrina Moss, Founder, Chaiya Art Awards

In 2016 my mother, Sylvia, was dying of pancreatic cancer. At the hospice I repeated to her a story that had been told at a friend's funeral, called *Water Bugs and Dragonflies* by Doris Stickney. Written to teach children about death, it resonated with my mum. However, what spoke to both of us was its vision of something beyond our comprehension and imagination. The story gave her a picture to align with her belief that death was not the end, but the beginning of another journey, one from which she could not return.

During that difficult and emotional time I yearned for a fresh vision for what I should do with the next stage of my life. The Chaiya Art Awards were the answer to my heart cry.

As with all big projects, it has been shaped by many people, for which I am hugely thankful. My aim through the Awards was to engage with artists to encourage them to create art that expresses faith and spirituality. Art has the ability to convey an idea, emotion or experience of God which is of immense value.

'Where is God in our 21st-century world?' is a challenging question in these difficult times. In the world today we see so much conflict and war; inhumanity; lack of care towards the young, the elderly, the disadvantaged, the vulnerable; neglect of the environment, and countless other concerns.

It is easy to think these issues reinforce the argument that there is no God, but I suggest that, in these often desperate situations, God is there to be found.

This book expands on the art showcased in the original exhibition and encourages us to go on a journey with this question. How will artists in our century, across many different mediums, engage with this subject: those with faith in God, those with none, and all those in between?

My prayer is that you will discover art that resonates with you and be blessed.

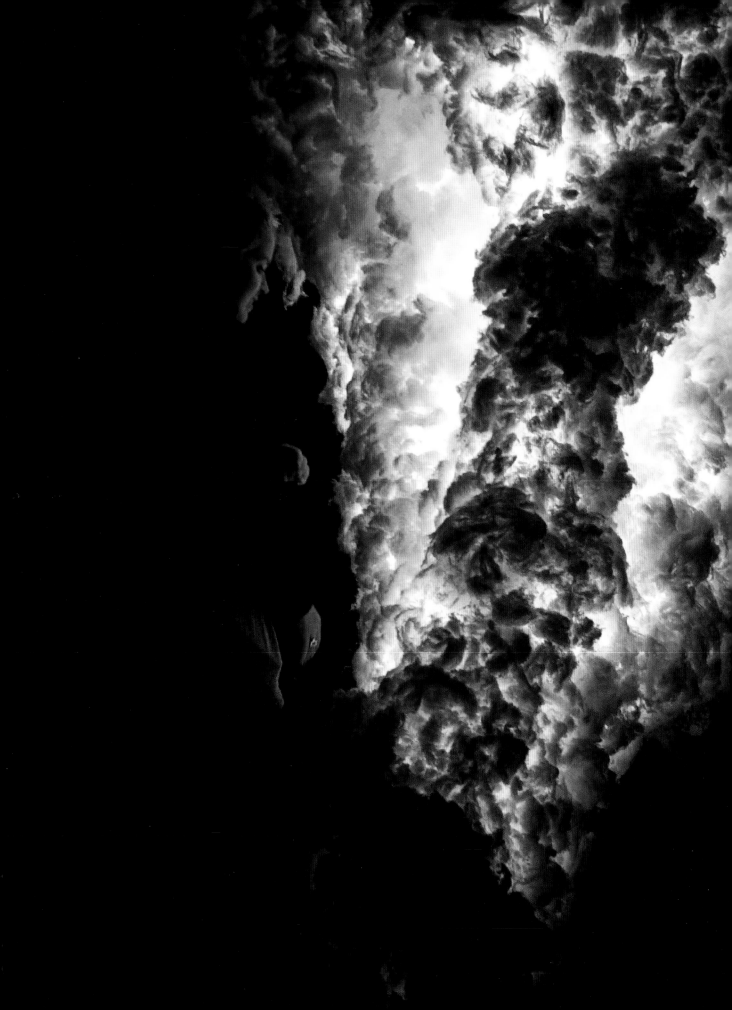

REALISING DREAMS

Katrina and I have been friends for thirty-five years. During that time we have embarked on many adventures. There's the one about the ugly sisters, the Cannes Film Festival, the short film starring the chicken, and the feature film, to name but a few. Our friendship has been the seedbed of much. Along with the encouragement of our husbands, it has endured painful disappointments, fabulous highs and the extremes of stress. There is something wonderful about friendship that withstands the best and the worst that can be thrown at it.

This project has been a labour of love for us. We have sought to encourage artists and all the Arts for as long as we can remember. Over the years we have brought practitioners together to sustain and embolden each other and, of course, in the process we have been enriched ourselves.

We rejoice together in the opportunity to realise a dream, to encourage excellence and the creation of resonant, spiritual work. From the small place of friendship anything can happen. May practitioners in the Arts be loved, accepted and revitalised.

EXPLORE

When I was seventeen and working in London as a secretary, I saved my money to leave England and embark on a course to learn French in Montpellier, France. For me it was a bold decision. I teamed up with a fearless Dutch student, and she and I determined to stay on after the course and found work picking grapes. Eventually we both sought work in a Paris full of student unrest. At any moment you could turn a corner in the Quartier Latin and come face to face with a squad of riot police. Not for the faint-hearted. Heady times.

She and I embarked on a trip to Amsterdam. We had little money so we hitched our way from Paris.

Through my friend I discovered the Rijksmuseum, and there I had my first visceral experience of an original painting. I turned a corner in that wonderful museum and came face to face with a painting most of us know: *Sunflowers* by Van Gogh. It literally took my breath away. I had seen numerous copies of it. I 'knew' it. But now I experienced it. The sunflowers seemed to extend out of the painting. There was something disquieting about them as if hope-filled beauty contained undercurrents of menace. I stood transfixed. This was what life felt like to me. The charisma of the actual painting was unforgettable. At that moment it was as if scales dropped from my eyes and I became an explorer. We hope this book excites the 'explorer' in us all.

> **'One does not discover new lands without consenting to lose sight of the shore for a very long time.'**
>
> ANDRE GIDE[1]

Where is God in Our 21st-century World? seeks, through art, to uncover where and if the sacred inhabits the ordinary.

Let us be humble seekers and, whatever our beliefs, explore. Let us take a moment from the activity and turmoil, the stress and responsibilities of our daily living and engage our hearts and minds in a different way.

We ask, can art and faith impact everyday lives? Can art open up fresh conversations about life, about spirituality?

In this book the artists display vulnerability, brokenness, lostness, wilderness and the 'Deeper Magic' first posited in The Chronicles of Narnia. Together, perhaps, we may choose to look beyond ourselves and acknowledge both doubt and faith.

The different headings throughout this book are an attempt to provide some bridges on a multifaceted exploration. The art, of course, will speak for itself, but the words also 'paint' pictures that reference the theme. I hope they will inspire fresh thoughts and new perspectives, and provide 'glue' to enhance and display the talented contributors.

Together we can wander and wonder, allow space for unknown questions to rise within, to release the need for answers, to encounter mystery.

QUESTIONS

For some of us, looking at modern art creates a heart and mind confusion. Panic sets in:

'I don't recognise anything.'

'What's it about?'

'I don't understand.'

'Do I like it? I don't know.'

Learning to look takes time. The artist began with nothing so every mark made, every form created, every shape honed has been done with purpose. Notice everything. Often we 'scan look' because we are frightened we won't understand. We feel small and inadequate so we race on to the next piece. We hope to find something we recognise and can respond to..

Take a deep breath. Trust yourself. Look.

Read what the artist calls the piece and what is written about it

Look again and then interrogate yourself, because art can evoke all sorts of things within us if we let it.

'The artist's mission must not be to produce an irrefutable solution to a problem, but to compel us to love life in all its countless and inexhaustible manifestations. If I were told I might write a book in which I should demonstrate beyond any doubt the correctness of my opinions on every social problem, I should not waste two hours at it, but if I were told that what I wrote would be read twenty years from now by people who are children today and that they would read and laugh over my book and love life more because of it, then I should devote all of my life and strength to such a work.'

LEO TOLSTOY[2]

Does it evoke a mood? Is it a mood you recognise?

Do the feelings of the artist emerge? Are they enraged, hurt, compassionate, playful, still, faith-filled?

Does it access spirituality?

Art can be ambiguous but perhaps the piece suggests an idea or several ideas. Like a many-faceted jewel, does it depend upon how it is held to the light?

Is the artist referencing a particular event or memory? This could be a memory in the public psyche or a personal one that tugs at one of our memories.

Perhaps the piece bypasses mental thought and slips straight into the subconscious, viscerally speaking to us.

Has the piece broken boundaries within us, with its form, its voice?

How do you feel about the craftsmanship it displays?

Is it beautiful?

Do you like it?

Or perhaps it doesn't look like art to you and it evokes nothing. That's okay. Turn the page.

OUR STORY

I began in my introduction with a snapshot of the story of Katrina and myself. We all have a story. Our lives, reflected in our faces, hearts, minds and bodies, outline a map that mirrors our journey.

How would we tell our story? Would we display a 'perfect' and enviable life on social media, redacting any sense of isolation, loneliness, friendlessness, disappointment or gut-wrenching pain?

We struggle in relationships, to be vulnerable, to trust. We are terrified of someone knowing everything about us. We remain sure, should we reveal our faults, our foibles, our deepest selves, that we would find ourselves alone. Most of us believe we are unlovable, so we paddle, like dogs in deep water, struggling to keep our heads clear and hoping to find somewhere to land and stop.

We search for safety, for companionship, for a shared experience of life, for love. The complexities of learning to live as independent, self-resourcing

> **'Man now realises that he is an accident, that he is a completely futile being.'**
>
> FRANCIS BACON[3]

human beings are huge. Our world, now shrunk, has many delights, but the economic reality is tough and we must work. For some, work is a delight; for others, it is an accepted necessity; for others, a stark and difficult reality that eats the soul.

Is life about work? I mistook it for such.

Is life about experiences? About fulfilling that long bucket list?

On our deathbed will we wish we had spent more time at work, visited more places, or reach out to hold the hand of a loved one?

What is your story? If a dynamic screenplay were to be written about you, what would it include? In film, the prime question for the protagonist – ie, me or you – is, what do they want? They may fail, but the want propels the story forward.

With a strong want, obstacles occur to stop the protagonist achieving their goal. A turning point takes the story in a completely different direction.

More hurdles and struggles, the distractions and diversions of 21st-century life. Choices disrupt direction. The choices of others dislocate life into something unforeseen. As you find yourself becalmed and in jeopardy on an unforgiving sea without a life jacket with nothing to hold on to, what twist could a screenwriter incorporate to save you?

Some may say our stories reflect that life is meaningless. We humans are of no importance in our struggle for existence on this tiny pinprick of a planet moving in a vast, ever-expanding universe.

God can become the 'whipping boy' on to whom we hurl all our pain, confusion, hurt and discomfort. But we are frustrated at the notion that our lives mean nothing. Something within us kicks against Bacon's assessment.

Most of our stories display extraordinary resilience and we find tender meaning in our lives.

'The poet's eye, in a fine frenzy rolling, Doth glance from heaven to earth, from earth to heaven; And as imagination bodies forth the form of things unknown, the poet's pen turns them into shapes, and gives to airy nothing a local habitation and a name.'

WILLIAM SHAKESPEARE[4]

Love, we discover, offers coherence. It opens the door to an enchanted realm.

As we discover how to give and receive, love reveals fresh vistas. Love riffs on notions of peace, of home, of comfort, of belonging. Human love is a portal to something much bigger.

This book invites quest. There is a saying, 'There are no atheists in foxholes.'[5] Pinned down in a bunker, you might cry for your mother or to God.

Where is God in Our 21st-century World? is a collection that cries from the heart.

Some believe, finding solace and love in the God they cry to; others do not.

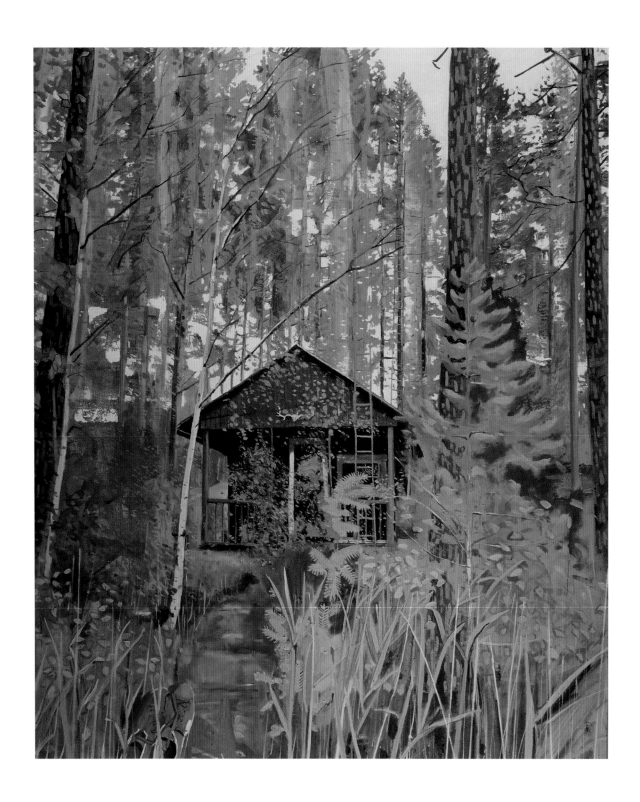

SEEK AND YOU SHALL FIND
Karl Newman
Oil on canvas
H:140cm W:118cm

Pressures compete within our busy and confusing world demanding our attention, time, money and resources. In the ancient forests of north Sweden lies an isolated, rudimentary fishing hut accessible only by foot. There, deep peace is made manifest in stillness; the unpolluted light revealing the star that leads.

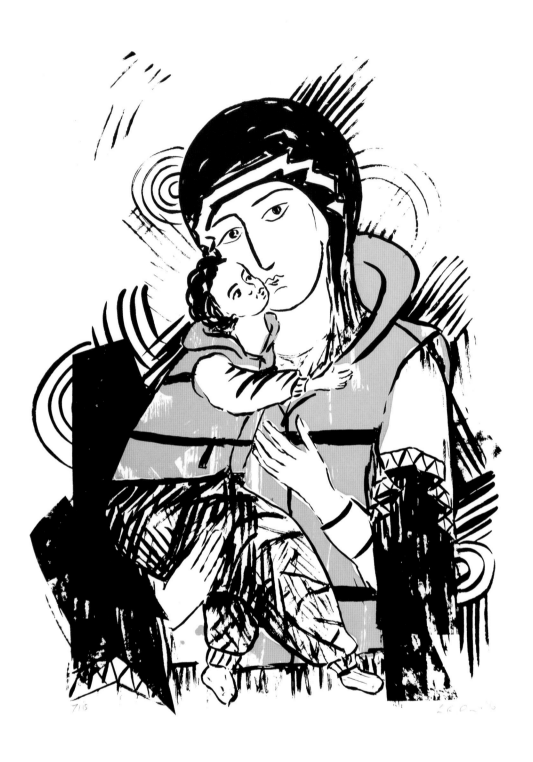

THE EXILES | A silkscreen re-sets an iconic image of spiritually
Louise Davis | charged and vulnerable motherhood, deeply
Screen print | familiar to both modern and ancient Mediterranean
H:52cm W:37cm | religions. Made for all those who search for safety
and sanctuary and those that aid them. God is to
be found with the most vulnerable.

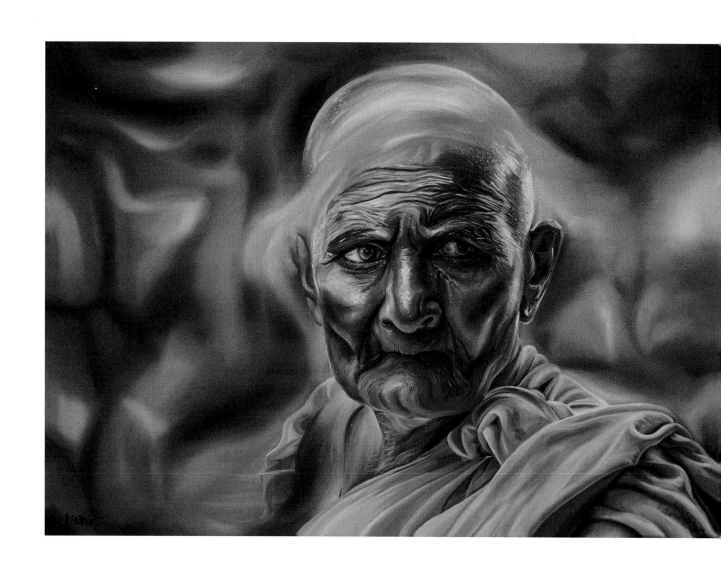

ENLIGHTENMENT
Heather Christie
Oils
H:50cm W:70cm

The Four Noble Truths of Buddhism explain how suffering comes from being attached to the things we do not/cannot have. The more we have the more we want. The disintegrating monk reflects the transience and impermanence of life.

BEYOND THE EDGE OF GONE
Andrew Crawford
Digital photograph giclee printed on Fotospeed
Platinum Matt fine art archival paper
H:53cm W:53cm

Profound and constant change is a feature of our 21st-century world. Blind to the direction and future, can we trust unconscious collective humanity or is there a greater unseen plan? In the midst we are powerless. Can we trust there is nothing to be feared?

WILDERNESS
Hannah Campbell-Wharam
Oil on canvas
H:110cm W:70cm

A personal narrative of coming
to understand that God calls us
'differently to each one' and we are
called to seek out others because he
sought out us first.

PATHWAYS
Karen Weatherbee
Resin, Acrylic, Metallic
Embellishments, Collage on
MDF framed
H:64cm W:94cm

Intense colours and textures map a version of the cosmos and animate our choices of movement through it. Has science superseded belief in faith? The work describes a multiplicity of routes and intersections through which, with our freedom of will, we may choose our own path.

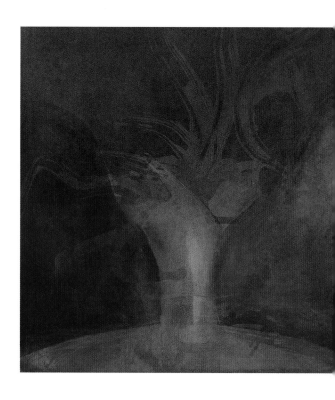

ROAD TO TOMALES POINT
Richard Stott
Oil and acrylic on canvas
H:74cm W:104cm

A road trip along the Pacific Coast of California meditating on the ocean and wilderness. As the fog rolled in, the artist experienced a moment of transcendence – of connection to God and place and deeper understanding of self.

OUT OF THE SACRED SPACE 2
Joy Hillyer
Acrylic on panel
H:40cm W:40cm

Through abstraction, this image explores the rugged and isolated landscape on the way by boat to the Rainbow Bridge, Utah (a sacred site for five Native American nations). Colour and form seek to convey a sense of the numinous which can be experienced by the 21st-century traveller.

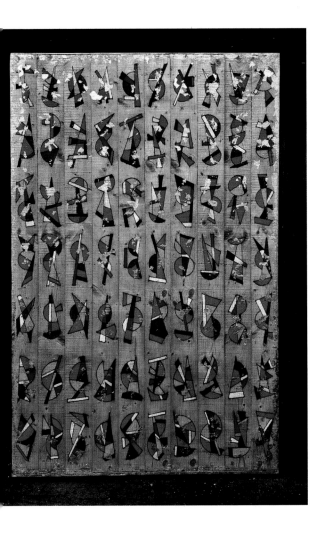

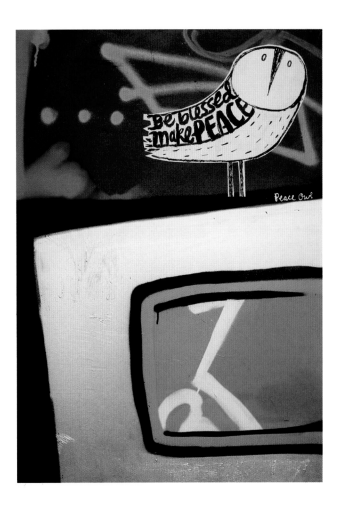

ARK | 194 permutations of
Robert Koenig | coloured sails portray
Painted wood construction | movement and change
H:154cm W:100cm D:39cm | as fundamental human
processes. The cost of such
searching remains implicit
and unfulfilled: if the goals
of our movement are both
an escape and an arrival,
how do we recognise a
destination when we have
reached it?

PEACE OWL | The owl, a symbol of
Tim Warnes | wisdom, perhaps a mascot
Spray paint, | for the 21st century. In these
collage on canvas | days we need those who
H:100cm W:70cm | observe; who speak of love;
who tell of the things of
God in contemporary and
accessible ways. Here is a
Peace Owl paste-up as the
artist recreates a placement
from the Leake Street Graffiti
Tunnel, London.

NATURAL ORDER

The sound of beauty in the natural world

A thundering manifests, sensible only to the keenest ear. The sound of impossible tiny thread-like feet battering the casing which enfolds it.
A resounding crash heralds the split which, once begun, tears open and from the pupae a head with expectant antennae, explores, tastes, smells, the fresh environment into which it will propel itself.
The tearing and groaning reveals a glorious iridescent blue morpho butterfly expelling itself into space. Magnificent wings beat as resonant jungle drums.
Freedom echoes.
A new creature birthed.

LAMENT

There was a time when beauty
spun around you
three -
golden threads
twinkling
on breathed-out life.
You could not be confined
so great was originating energy.

We walked together
Man and Maker
our oneness moved and lived
within and without.
Delight etched itself in the
slivers of laughter -
sounds breaking like tinkling
bells
among and contained by loving
loveliness.

Wonder rotated above and
below
without measurement or equal,
number or notion,
a being content within an
unnamed order
through which they danced.
The dance of love turned on
an axis of simplicity.
There was no remembering
because nothing had yet been
forgotten.

Why did we stop our ears
to the music?
Create steps
never meant to be danced?
Our fumbling self-
determination
choreographed for each a solo
path
to our dance of death.
Perhaps knowledge demands
opposites.
The easement and embrace of
love
remains unfulfilled,
misunderstood,
an untimely puzzle
without proximity to hate?
The one grows fat and bloated
eating living flesh.
The other parcels sacred offal
dipped in humility.

Released the monster gorged
Ripped children from their
mommas' arms,
Spread my grandmothers',
mothers', sisters', childhood
legs
Sank knives, bullets, bombs
to rip apart my
grandfathers', fathers', brothers'
flesh.
Befouled the black skin of my
family -

tortured, hung and quartered
them.
Sank its teeth into the ocean;
Squatted, soiled, dug and
desecrated;
Insatiable, execrable, defecating,
perpetual motion.

We lament our voraciousness
our deep remembering
becomes a ghost
that haunts.
We cast our net of hope
on empty seas.
Our condition makes no sense
Meaninglessness a sombre
bedfellow
Our wakes attach themselves to
oblivion.
What of Love
stood in the pathway of such
intransigence?
Devoured,
disfigured,
dishonoured,
decoupled,
downgraded to an earthly
ugliness.

Embodied Love defies
everything.
Eaten it becomes a Socratic
cup

and the monster's limbs
fragment.
Life blossoms.
Hearts strain to hear
the long-forgotten creation
music.
Hearts yearn to live forever,
eternity beckons,
but where is the portal?

Hope is the mould of faith
created by a Messiah/man.
Each moment of his life
imprinted on the cast
within which to throw our
trust.

Time reverberates backwards
and forwards -
a pendulum of life
upon which to place our
courage
in the face of rampant unbelief.

The rewards of faith are
beyond imagination.
The simple solace -
an unadorned,
vulnerable,
naked,
beautiful creature
in harmony with Creator.

'Millions all around us
are living the tragedy of
meaningless life,
the "life" of spiritual
death. That is what
makes our society most
radically different from
every society in history:
not that it can fly to
the moon, enfranchise
more voters, have
the grossest national
product, conquer
disease, or even blow
up the entire planet, but
that it does not know
why it exists.'

PETER KREEFT[6]

PRICELESS

As the Queen celebrated her coronation and recounted details of the day in a BBC interview, before her sat the Coronation Crown: the Imperial State Crown, existent in various forms since the 15th century. Her father had worn the current version, constructed in 1937, at his coronation. Made of gold, silver and platinum, it weighs 1.06kg. Its most notable stones are the Cullinan II Diamond and the St Edward's Sapphire. Many other precious stones adorn this crown, fit for a well-loved queen. It is priceless. Only royalty will ever wear a bejewelled crown.

Although my personal world is comfortable, I see many people who are homeless, hungry and struggling to maintain a life for their loved ones. I walk the streets in the early hours of the morning and find the disenfranchised living on the edge, with social care withering around them. How much are they worth?

We pass the marginalised all the time, and more people than we think contribute in their way. I have been witness to boxes of food bought and stacked up beside a street person. Provided with food, many long for company and a listening ear. Their stories are often horrendous. They own up to frequent bad choices and much loss. To touch or to hug them, offering a moment's empathy, brings tears to their eyes. And yes, there are those who swear and shout and want no contact. Do they have any value?

'Solitude is not something you must hope for in the future. Rather, it is a deepening of the present, and unless you look for it in the present you will never find it ... We have thinking to do and work to do which demands a certain silence and aloneness. We need time to do our job of meditation and creation.'

EDMUND DE WAAL[7]

Foodbanks rely on the kindness of ordinary people. We give to charities. Most of us care. The urge to contribute into our society is greater than we, the cohabitants of this island, are often given credit for.

There was a prophet named Isaiah who talked of a priceless crown. This crown different to the Queen's. This crown is available to all – 'a crown of beauty instead of ashes'.[8] The writer means that all lives can be infused with loveliness through faith. But there is also a custodian of such a crown. Someone who can make beauty manifest. The artist.

Many artists desire to contribute into a hurting world. They do not necessarily bring actual food. They may have little money to give, but they can bring beauty. Loveliness is a different food. It is food for 'the soul'. Food the natural world delivers time and time again. It is food we cannot live without.

We human beings cannot survive on ashes – the 'things' and 'stuff' of our consumer society: horror, abuse, degradation, isolation, sickness, objectification. Or social media with its poisoned ashes of language that defame and destroy the chosen offender. The murmuration of electronic clutter, while essential, overtakes and dulls.

We need food that empowers, food that causes us to lift our eyes beyond the material, beyond the constant soundscape; we need beauty. It reminds us of our best selves, of the human spirit that can

dance on the creative wind; explore, laugh and remember what it means to be truly human.

Perhaps 'beauty' is an unfashionable word, but reflecting on loveliness and rising to its banner will cause us to despise the things that degrade, tear down, abuse, break and dehumanise which assault us every day. It is about seeking a quality of life, about human flourishing. Dallas Willard writes that beauty is 'goodness made manifest to the senses ... Nothing is more meaningful than beauty'.[9] Is that so?

If I stop and reflect on beauty, my list includes a seaside sunset, a laughing child, a vista of fields, a bird feeding its young, a mountaintop, a snow-covered slope, a pet, a symphony, a ballet, an elderly parent and so much more.

Beauty enlightens, envisions, empowers, emboldens. It affirms the loveliness within our humanity and reaches out beyond the earthly to a hovering spirituality, a ghostly remembering of something greater. A half-hope in the possibility of God.

Contribution into our common humanity is in our DNA. The artists, with their eyes straining, stand on the 'edge of the inside'.[10] They stand on the boundaries, the bridges and the entranceways. They gain critical insight into the human condition and remind us of our best selves. They see and think in ways that can effect culture change.

The noted journalist and theatre critic Benedict Nightingale wrote:

> The arts are a trade which can change hearts, mould minds,
>
> worry the entrenched, upset the tyrannical and nudge history.

It takes courage and authenticity to be an artist, as well as a deep sense of responsibility. The artist needs a language that does not reek of commercialism, of lies, and a cavalier 'so what does it matter' attitude. The artist needs to see their contribution not as money-making only, but as a sacred charge. 'The world is full of magic things, patiently waiting for our senses to grow sharper.'[11]

Truth-telling in a false world requires a generosity of heart, a deep sense of thankfulness for the gift given, a refusal to offer a commodity, and an open-handed desire to hunt and create beauty. We need to find new ways of seeing, and go beauty-hunting.

SEQUENTIA
Sue Lawty
Natural stones on gesso
H:137cm W:47cm

In a varying grid, uncountable fragments of rock are distinguished only by variations in their natural colour. Each speck of stone, lovingly collected, bears witness to the vastness of geological time rendering humankind the actual speck.

'I KNOW ALL THE BIRDS OF THE HILLS, AND ALL THAT MOVES IN THE FIELD IS MINE'. PSALM 50:11
Elisabeth Rutt
Original dry felted fabric with
screen print and hand stitch
H:46.5cm W:31cm

White chalk lines left by both natural geology and our impact on the environment are the starting points for this work, whether strata, ploughed fields or paths. We have a fundamental responsibility to care for our world, and evidence of our impact can be seen in references to buildings and agriculture. Meanwhile, birds soar free over open country.

FLORESCENCE | Mosaic forms burst towards us. Bees, insects and flowers play a
Sue Smith | vital role in our existence. This large, colourful, intricately made
Stained Glass Mosaic | sphere represents our world. It is created by small, uncountable,
D:120cm | new and recycled pieces of glass which together illustrate the
| continuation of life and where it all began in 'The Garden'.

ALBEDO
Trudi Lloyd-Williams
Mosaic
H:135cm W:30cm D:7cm

The layering and tonal values of this mosaic depict how global warming is changing the landscape of Antarctica, where ice core samples have revealed rapid ice loss. The bands of clear whites and blues symbolise the high levels of reflected light in pure snow and ice, the deepening greys the diminishing light reflected in mud. A seam of gold tesserae running the length of the piece expresses a hope that some might call God.

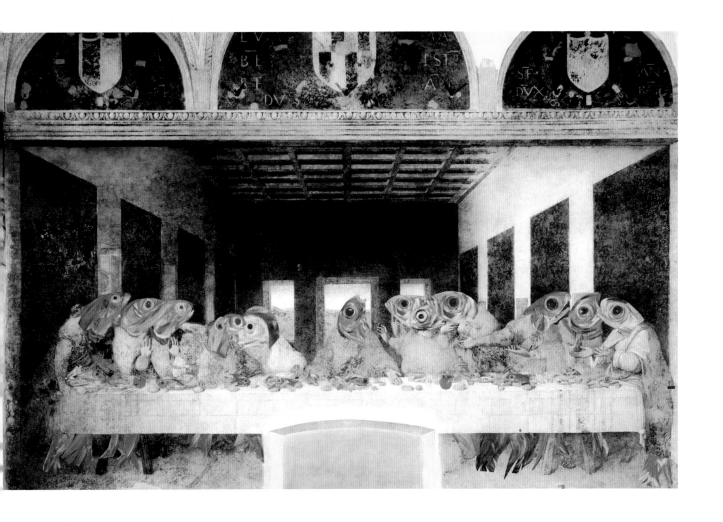

THE LAST FISH SUPPER
Gina Parr
Photograph printed with archival ink on
Hahnemuehle 310gsm paper
H:81.4cm W:105.8cm

Fish stocks worldwide are dangerously depleted and church congregations in the Western world are falling. How many more fish and chip suppers will we enjoy and how many times will we gather for Communion? Making use of the fish as a symbol of the Christian faith in a reworking of Leonardo da Vinci's *The Last Supper*, the artist makes a plea for our spiritual and physical worlds.

THE GARDEN
Sarah Kelly-Paine
Oil on canvas
H:50cm W:50cm

To the artist, the Garden is a place of rest and peace, of communication, of biodiversity and beauty, of perpetual transition and change. It reflects the nature of its Creator. It is a place of connection with our spiritual selves, with each other and with our Creator.

SEEN (RESONANCE SERIES)
Mark Cazalet
Oil colour on paper
D:110cm

As a form of creation, the artist refers to painting as a basic 'turning towards light'. Here, such turning rejects directionality. It also relinquishes both shape and scale for its image. Light approaches from everywhere and colours a fleeting negotiation between the viewer, the artist, the 'seen' and the message.

ETERNITY IN THE MIND OF SOMEONE LIVING
Craig Jefferson
Oil on canvas
H:165cm W:122cm

God, who has made everything beautiful in its time, has set time and eternity in the human heart. The seated figure considers eternity as he gazes at the void between his outstretched hands. For a moment he is taken to an unseen, but always present, parallel place.

THE STORM
Chris Evans-Roberts
3D sound and light installation, sculptural
Up to 5 metres long

For years, humankind has seen the power of natural phenomena as representative of the majesty of the God voice and presence. Five metres of cloud covering billows from ceiling to floor with 6,000 individually programmed LEDs, plus a roaring soundscape, recreating the majesty of a close-range thunderstorm.

WANT & WORSHIP

'What gets valued gets measured,' goes the saying.

'How do I spend my time?'

'What consumes the bulk of my mental and emotional energy?'

'What do I do with my money?'

'Who or what do I love?'

At heart we are insatiable. We do so much to feel full and yet we are impossible to satisfy.

Some youngsters and adults desire to 'be famous'. This goal focuses all thought, energy and expression. They buy into money and adulation. Use of social media aids us as we create a version of ourselves to be 'liked'. Things are photographed and shared to make us appear of more value than others. Our real life is shamed into hiding.

A default, unconscious way of living sets 'I', 'me', at the centre of the universe, and the poverty of our soul increases. We need to discipline our choices. To think, to look, to reconnoitre so we walk with intelligence, with our eyes open. Life's secrets must be mined to yield a rich and varied life. 'Seek and you shall find.'[12]

I love solitude. It is the place of power and energy that propels me into the spacious landscape of my imagination. It is a place, for me, that demands silence. Alone, it deepens my present and unfolds before me an ever-increasing spiritual warehouse.

> 'The place where your treasure is, is the place you will most want to be, and end up being.'
>
> JESUS CHRIST[13]

It fills me with wonder. Here I examine what I do, which tells me what I want. Wants line up and survey me. Greedy, their mouths are open and wide to eat… me. It shocks me.

There is a story of a God–Man, who went without food or water for forty days.[14] At his weakest He needed and wanted much. He was offered three things.

The first was food. We human beings are born hungry. Hungry for food, for love, for sex, and we are voracious. We grow fat on wants, but few of us are satisfied. We fail to understand the state of 'enough'. This man could eat food if He would 'magic' it out of stones. But His mission was not to feed Himself, and He would not.

The second was to prove He believed. If He were to fling himself to His death, He would not die. He was a man, and men who do that die. Death must wait. Timing was everything. There was to be no bargaining, no ego; He knew who He was. There was nothing to prove.

The third contained a pact. To give Himself to that which could never deliver, only consume. Life cannot be bought with anything shiny. It can only be given to empty hands.

But my hands are full.

FULL

I

Me

Mine

Not you

Not him

Not she

Not her

No we

No us

No they

No them

Only me

I

EMPTY HANDS

WORSHIP

My son was six when he saw a beggar for the first time in our town. He asked what the man was doing. I explained that life must be very difficult for him. He was asking for money. When we arrived home, my boy said he wanted to give the man the contents of his money jar. Everything in me craved to discourage him from giving all he had. I didn't. I kept my mouth shut.

My son carefully decanted all his change into a small plastic bag. We walked back together and he handed it over. The man nodded and turned away. He did not understand how big the gift was for my son, but the gift wasn't about receiving thanks.

It was the first of many lessons my son taught me regarding generosity.

Like humble snails, we carry the darkness of the world on our backs. As we travel we find injustice, pride, hardness of heart, complacency, hypocrisy, idolatry, shallowness, faithlessness.

Our wants will destroy us and our world, and yet we gift them. We decorate and collect them. We make altars to them and prostrate ourselves before them.

The tools and gifts of our worship are reminiscent of used bones, sucked clean, dried out, weathered white. As they are heaped on the altar of our want, they become the filter that denudes our souls. We raise our arms in wonder before the dead things. We stretch ourselves out. Our awkward vulnerability strips us clean and threatens that we too will become whitened and dead. We become what we worship.

'Can these bones live?' speaks a voice of faith that resonates through the ages. A man called Ezekiel in conference with God.[15]

In answer, a rattling was heard. If we look, it will not be the bones without but the bones within. The rattling heralds the breath of life.

Can we listen to our deepest longings?

Will our bones quail before a moment of courage?

Can we inhabit the dreams that will arrest our starvation?

Will we allow mysterious questions to arise like bubbles and catch them before they disintegrate?

Will we give ourselves the space not to frame the emptiness which terrifies us?

Breath.

Breathe.

If we breathe this breath, in our helpless nakedness our bones may yet come together with sinews and flesh, and fresh life infuse our being.

'Because here's something else that's weird but true: in the day-to day trenches of adult life, there is actually no such thing as atheism. There is no such thing as not worshipping. Everybody worships. The only choice we get is what to worship. And the compelling reason for maybe choosing some sort of god or spiritual-type thing to worship — be it JC or Allah, be it YHWH or the Wiccan Mother Goddess, or the Four Noble Truths, or some inviolable set of ethical principles — is that pretty much anything else you worship will eat you alive. If you worship money and things, if they are where you tap real meaning in life, then you will never have enough, never feel you have enough. It's the truth. Worship your body and beauty and sexual allure and you will always feel ugly. And when time and age start showing, you will die a million deaths before they finally plant you. On one level, we all know this stuff already. It's been codified as myths, proverbs, clichés, epigrams, parables; the skeleton of every great story. The whole trick is keeping the truth up front in daily consciousness.'

DAVID FOSTER WALLACE [16]

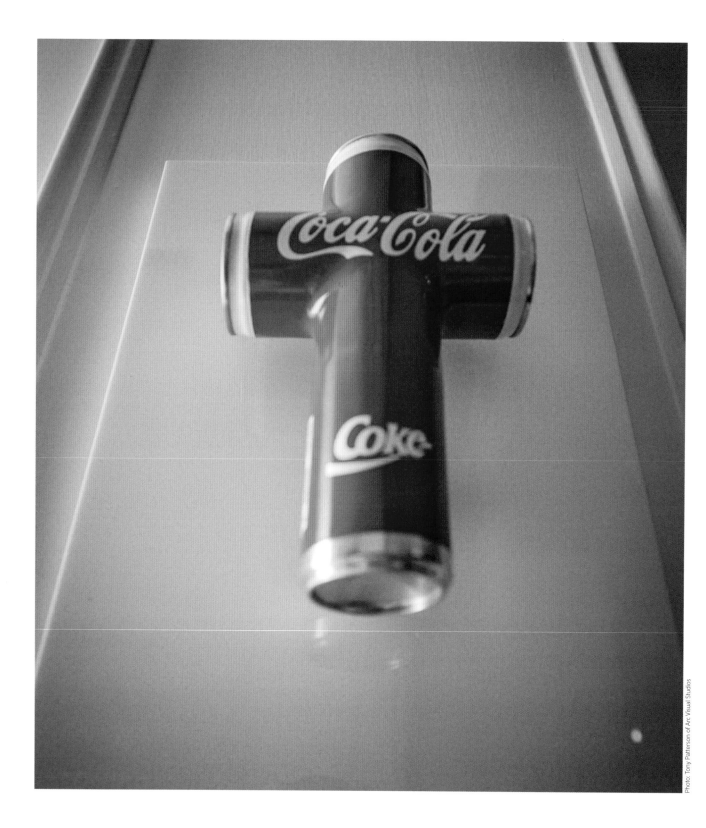

THE REAL THING
Simon Shepherd
Aluminium and plaster.
H:40cm W:30cm D:12cm

Two global icons – the cross and the Coca-Cola brand, both claiming to be The Real Thing. What do we worship in the 21st century? Has the focus shifted from worship of the spiritual to worship of the material? Can we see what is 'real'? The piece poses radical questions.

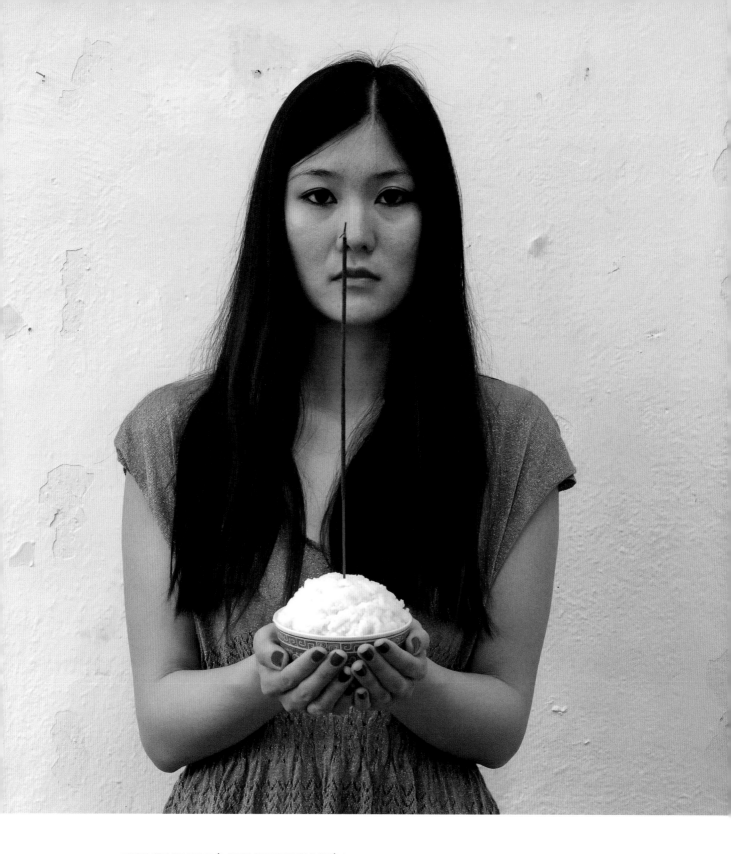

THIS IS MY GOD (WITH HSINYEN WEI)
Ana Mendes
Photography
H:42cm W:59.4cm

This photograph is part of a wider project that Mendes undertook with immigrant communities exploring objects that represented God to each participant. In Taiwanese religious culture, rice and incense have ritual significance. The title of this serene and simple photograph includes the name of the woman, retaining her particularity and identity.

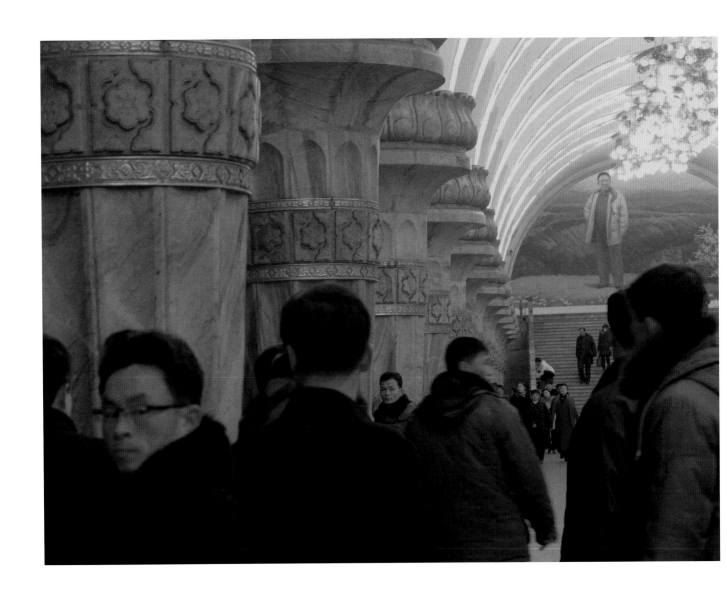

KORYO
Yue Wang
Photography
H:38cm W:50cm

North Korea's population is expected to express an almost religious devotion for their infallible leader, who watches over them from a vast idealised mural. Here, on a winter's day in Pyongyang, the atmosphere is cold, fearful and suspicious of the stranger taking this photograph. Perhaps beneath the surface is a desire for something deeper, something genuinely divine.

I KEEP GOD HANDY IN MY LITTLE BOX
Mike Fryer
Acrylic on wood panel
H:30cm W:30cm

There is an attitude of keeping God accessible for when disaster comes. When it strikes, the box is taken down from the mantelpiece, opened, used and then replaced. God is often ignored but He does not change.

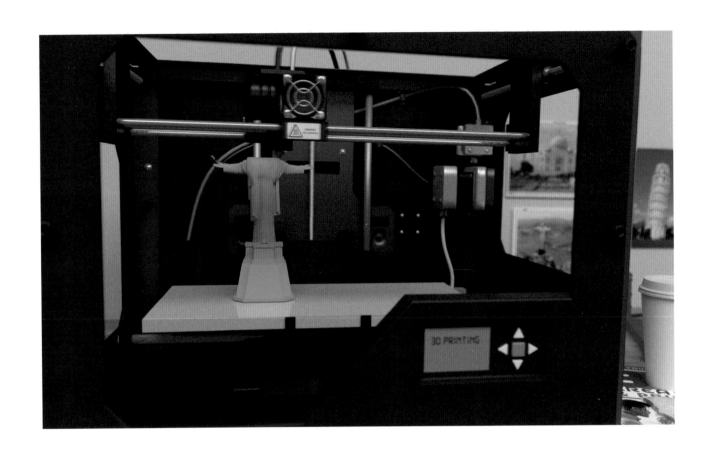

MODERN WONDER (VIDEO)
David Theobald
Time: 3mins 39s
Available to view at:
www.chaiyaartawards.co.uk/video

A 3D printer creates a green plastic miniature statue of Rio de Janeiro's iconic 'Christ the Redeemer'. Technology can be a double-edged sword; a great leveller and emancipator, yet also an object of worship itself, with its ability to thrill and create apparent perfection.

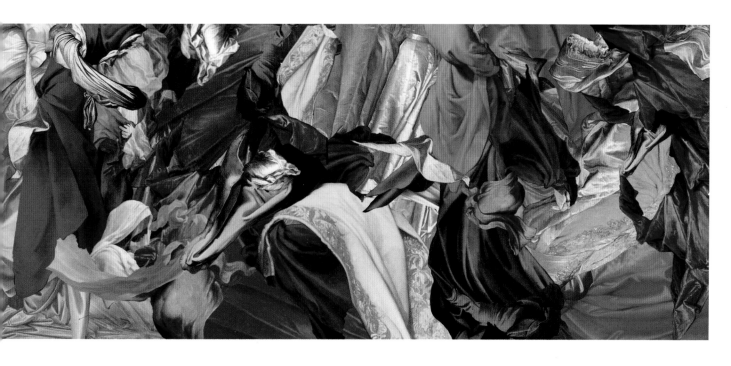

SHROUDED IN MYSTERY
Stephanie Wilson
X2 digitally printed velvet fabric pieces
H:40cm W:100cm

A churning mass of exquisite fabrics refers to absent forms that nonetheless define their shape. They are the subordinate elements of religious paintings. Collected digitally, they now assume the dynamic entirety of their own composite image. Expressing a contemporary engagement with religion, they demand reflection.

QUANTUM CONSCIOUSNESS
Jasmine Pradissitto
Mixed media – light, polarising filters, recycled plastic, plastic
H:35cm W:35cm D:20cm

With more technology and larger brains, we require more sophisticated narratives to explain why we are here and what our purpose may be. We were made in His image ... Perhaps we are our own gods; creating our existence through our very consciousness which, although it exists inside our heads, is as mysterious still as the furthest reaches of the universe.

VAULT YOUR AMBITION
Lee Simmonds
Oil, charcoal and inkjet on canvas
H:150cm W:260cm

An altar piece to neo-liberalist solipsism – the philosophical theory that the self is all that you know to exist.

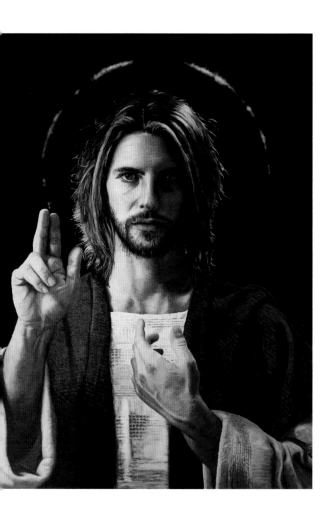

JESUS IN HOLLYWOOD
David Millidge
Oil on canvas
H:114cm W:90cm

Jesus is posed traditionally but this is the Hollywood version. Handsome, tinted hair and a blue-eyed gaze to penetrate your soul.

DANCING SHOES
Lazaros Pasdekis
Water mixables oils
H:80cm W:60cm

Is God Love? Is God Power? Is God Cruelty? The artist's work is about God in the subjective form of beauty and aesthetics. Bombarded by materialism, even a simple, humble, shoe colour reminds us of a greater beauty behind our glossy world of mass production.

BROKENNESS

The Japanese art of Kintsugi is the art of repairing broken pottery with lacquer dusted or mixed with powdered gold, silver or platinum. The philosophy of highlighting or emphasising imperfections, visualising mends and seams is to acknowledge the history of an object rather than disguise it. It contains subtlety, elegance, mystery and a quest to find beauty in imperfection. Wounds are gilded and imperfections, perceived as beauty, embraced.

As human beings, we are impermanent on this earth. In the midst of beauty and decay, all things change and develop. In decay there is a beautiful becoming. Time ceases to be an enemy. Space, pause and silence are welcomed and encompassed, exploring the possibility of ordinary life exhibiting a fragile loveliness and simplicity.

It is a celebration of healing and story brought about through our wounds, brokenness and flaws.

THE SPONGE AND THE SHRIMP

In the deepest part of the ocean, as David Attenborough explains in *Blue Planet II*, there is a stunning sponge called the Venus' flower basket. Composed of delicately laced funnels, it is home to the eggs of shrimps. In one funnel two shrimps grow and procreate, never leaving the sponge in which they have found sanctuary. Their companionship and living keeps them oblivious

'The most personal is the most universal, the most hidden is the most public, and the most solitary is the most communal. What we live in the most intimate places of our being is not just for us but for all people. That is why our inner lives are lives for others.'

HENRI NOUWEN[17]

to the fact that, should they swim out of their home, an entire world awaits them: a world of predators and danger, but also the possibility of exploration, discovery and wonder.

Time passes, and now neither is able to leave, even should they wish to. Grown too big, they are unable to exit where they entered. Their tiny world will never change. They will die in the home into which they were born and never chose to vacate.

Stunted creative thought and imagination keeps us as creatures of impulse and instinct. Do we make ourselves small? Do we cast aside the incredible depth, height and breadth of our creative and imaginative humanity to box ourselves into the mould of instinct?

Though the sponge was the shrimps' intended home, what if it were the incubator into which they needed to give birth and then leave?

Once gone, the shrimp could never return. Fear of the unknown always threatens to hold us fast, and regret is a poor bedfellow.

HOME.
WHERE IS HOME?

Is it somewhere where
the log fire flames
flicker away
Sitting cross-legged
Blankets on knees

Or is it somewhere
amongst the moon
And stars stretched out
on the grass?

Or is it a place where
There is shelter from the
storm?

Or is it in the forest
Dancing with arms
entwined around each
other?'

TEJ SIDHU [18]

HOME BOUNDARIES

Is it a place? Perhaps the house where we grew up? Has it been sold, demolished, or has it changed beyond recognition? Is it somewhere we go back to and rekindle old memories and long-forgotten feelings; a place where we can re-inhabit our past selves? A place where we might recapture a beloved face, or smell or scene?

Such thoughts make some of us recoil. The home of our childhood was perhaps one of abuse, mistreatment, turmoil, a litany of lost opportunities that severed emotional connection from loved ones, never to return.

Billy Joel sings poignantly in 'You're My Home' that he never had a place to call his own until he found love. The song is eloquent about the intimacy of being with his lover. Bodies and lives shared; however far they travelled or for how long, home now travelled with him. There is a lovely line about how sharing his life meant he could feel his withered roots fill with vitality and growth.

What if you don't find love? Or if you were to find love and it disintegrated? Where is home now? Can you remake home by yourself, alone? Many people are single in our culture, either because they never found partnership or because of the death of their partner.

In *The Wizard of Oz*, Dorothy poignantly reminds us that there is nowhere quite like home. She does return to those who love her. Some remain travellers in an alien world, misunderstood, sidelined, unappreciated.

Places are important, but I agree with Billy Joel that home is about loving others. Every human being longs for love. If we want love, then become a lover. Much love is needed in our world. This is not about sex. Sex without love or relationship strips us not only physically, but also emotionally and mentally. This is about loving those among whom we live: the marginalised, the dispossessed, the do-not-haves. They live next door, in our street; they walk our landscape. They are worn out, hanging on by fingernails, desperate for friendship or the warmth of a smile. Love transforms stranger into fellow traveller.

Home, I hear the cry, is being able to do what I want, when I want, being answerable to no one. You don't deliberately want to hurt anyone, but a self-absorbed life will leave a trail of destruction. You will find yourself alone.

To become a lover requires accepting boundaries. Choose the boundaries with care. A successful loving relationship entails commitment, honesty, transparency, time, effort, ingenuity, patience, forgiveness, kindness, peacefulness and self-control. It is not for the faint-hearted, but the rewards are great.

FEAR

PAIN

Our society screams things to be fearful of. Obvious things like terrorists, murderers, rapists, burglars, thieves, cars, trains. The less obvious bicycles, snow, leaves, climbing trees, dogs, cats, bees, eating too much, eating too little – an endless list growing longer thanks to health and safety and the fear of being sued.

Should we live like the shrimp?

We can see what the shrimp cannot. After all, it is only a shrimp! Creativity and art bring into being that which did not previously exist. Some of us are gifted to unlock, explore, imagine the unimaginable, and we should. A huge part of home for creatives is to make. Make, then.

'Having peace means knowing oneself borne, knowing oneself loved knowing oneself protected;

it means being able to be still, quite still. Having peace means having a homeland in the unrest of the world.

It means having solid ground under one's feet. Though the waves may now rage and break, They can no longer rob me of my peace.'

DIETRICH BONHOEFFER[19]

Some of us live with physical pain which envelops every fibre of our being. Shards shoot into limbs and we groan with it. Distraction is difficult because it is visceral and ever-present. Physical pain is exhausting, debilitating and frustrating.

There is other pain that is less recognisable, less accessible, but equally incapacitating. Our minds and emotions gallop in different directions, our mental state fragile.

There is the pain of disappointment, of waiting, of grief, of broken relationship, regrets, heartsickness. A sense of hopelessness.

There is the pain of victimhood and the struggle from the wormhole.

Pain is part of being human.

Jesus wept. And He continues to do so.

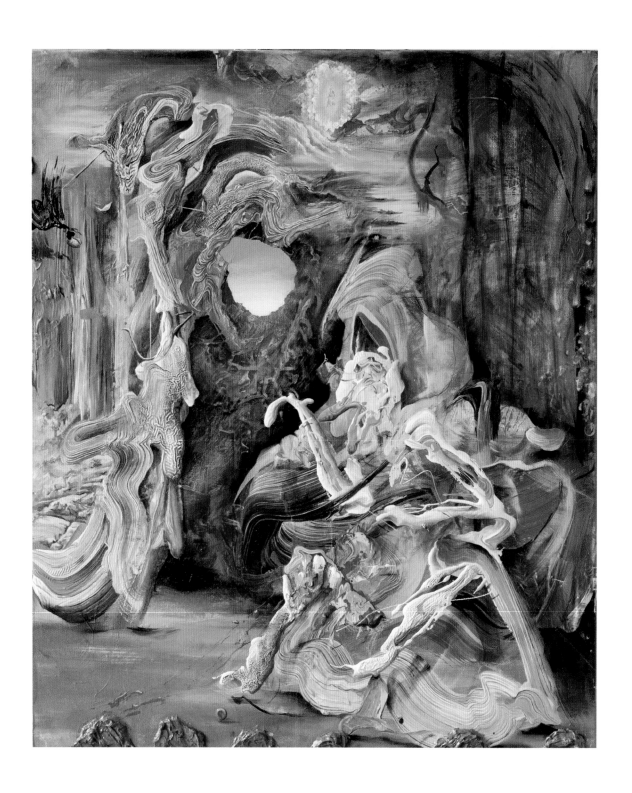

CORVUS CORAX (ST. ANTHONY)
Iain Andrews
Oil and acrylic on canvas
H:60cm W:50cm

Free markings of a brush and knife on canvas coalesce into an image. The fluidity of the paint mirrors the way that stories are told and retold, sometimes finding new meaning as they evolve. Here, the starting point for the story is that of the Desert Father, St Antony. Andrews' painting is informed by his work as a psychotherapist with teenagers.

LEFT OUT
Maxwell Rushton
Bronze
H:60cm W:60cm D:60cm

It's a shock to see the human form presented uncompromisingly as a bag of rubbish. Yet it is worryingly easy to lose sight of the humanity of rough sleepers and the homeless. This inert and vulnerable figure makes us ask, 'What must I do?'

GODLESS
Isabela Castelan
Photography, digital media/giclee
print on archival paper
H:20cm W:30cm

A single image combines time-based
performance with still-frame photography.
Its stark, blurred image appears to capture an
ongoing process of change and of desperation.
Here, the loss of personal faith is enacted as a
moment of absolute loneliness.

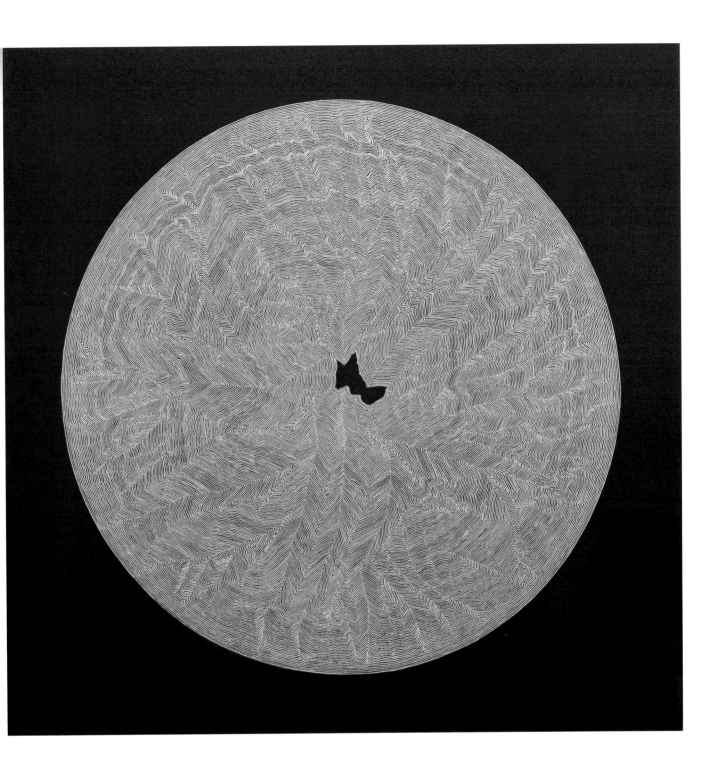

ADMITTING THE POSSIBILITIES OF ERROR #5

Kirsten Lavers

Ink on paper

H:62cm W:62cm

Begun as a perfect circle, this drawing progresses inwards line by line and integrates its own errors. Mistakes document learning, discovery and reconciliation. The Japanese philosophy of Kintsugi meaning 'golden repair' documents our scars and flaws finding beauty in the impermanent, incomplete and imperfect. Accepting ourselves allows acceptance of others.

SCARRED | God is in the cracks. Inspired by the Kintsugi, a Japapese
Rachel Ho | method of mending broken pottery with gold. Wounds and
Ceramics | scars bring hope of restoration and renewal in the midst of
H:10cm per pot | deepest pain. Therein is a mystery. Forty individual porcelain
pots form a group. In series, they are made, damaged and
finally mended with a more precious material.

GENES
Mandy Smith
Fabric sculpture
H:26cm W:76cm D:115cm

Using old jeans collected from friends and family, Smith modelled this figure on her body, while marking it with wounds experienced by her mother through episodes of illness and grief. Manifesting suffering in creating this figure, she witnesses to the shared love, life, doubts and beliefs of three generations of her family. The hand, a plea looking for God.

A THOUSAND BOTTLES OF TEARS
Deborah Tompsett
Ceramics

Hand-thrown clay vessels display varieties of
material and technique. Each pot formed from
a heart-sized lump of clay from baby to adult.
They are filled with handwritten messages and
then re-fired. Since the Davidic era, 1055 BC, tear
bottles have spoken of the sacredness of tears as
messengers of grief, contrition and love.

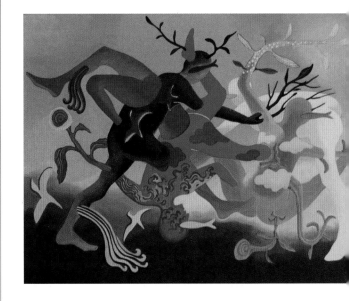

SOFTEN – 233542
Stephen Ritter
Acrylic on watercolour
paper
H:52cm W:72cm

In a painful ten-year
process of relinquishing
past learning and ideas,
the artist let go to
allow what cannot be
expressed to emerge.

HARMONY
Tsogt Otgonbayar
Acrylic on canvas
H:67cm W:87cm

This image fuses traditional
and modernist elements fro
Japanese, European and
Mongolian painting. It depic
the struggle of humanity to
find a more connected way
deal with the social, political
and environmental issues
surrounding us. Our fragile
existence is in the balance.
Faith and philosophical
understanding can help
maintain the balance neede
for our world to flourish.

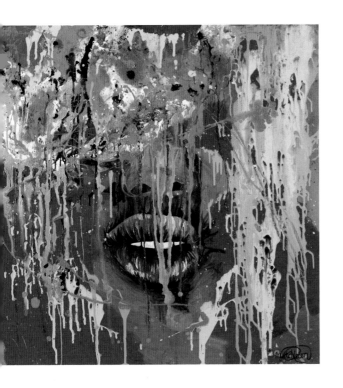

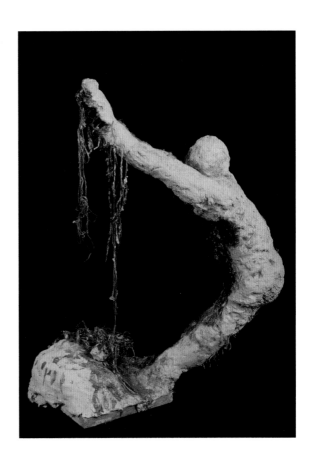

WOMAN AT THE WELL | Based on the Samaritan
Genique Middleton | Woman and her meeting
Acrylic, resin, ink and | with Jesus at a well. Rather
mixed media | than being despised, the
H:120cm W:110cm | woman discovers herself to
be accepted and known. She
is told there is living water
that will quench her thirst
forever. Often we satisfy
physical desire and overlook
our spiritual needs.

CLINGING TO HOPE | Composed of only two
Kate Crumpler | fundamentally different
Plaster, string | materials, this small figure
H:60cm W:48cm D:30cm | presents a study of a tensely
balanced weight and
counterweight that suggests
the struggle between faith
and certainty within life's
difficulties.

SUFFERING & DEATH

ABSENT

Absent when most needed.

when the baby died

the mother wasn't healed

the father didn't walk away from the car

the fire came and all was lost

Absent when His friend died

The anguish in the garden, when blood filled his pores.

The darkness of death made darker still

when God is not there when needed.

There is an outlandish God who promises presence without delivering the performance we want.

A preposterous God who loves to the point of death.

An unbelievable God.

In a world of tears there is laughter to be found. On the sound of the poor, the broken, the children, the madmen and the fools skims the Presence who hears the unlikely, the least and the lost and weeps until there are no longer tears, because in the midst of death He is always present to bring life.

Listen.

In silence let the stones cry out.

Shhhhhhh.

Dear God,

Instead of letting

people die and

haveing to

make new ones

Why don't you

just keep the ones

you got now?

jane

CERTAINTY

There is only one certainty in life: we will die. It is a subject we hate to discuss, to face, to prepare for. If you knew the precise moment of your death, what would you choose for your final meal?

Mat Collishaw created a series of photographs in the style of Dutch 17th-century still life. Some Dutch artists communicated death through their still-life paintings using images of decaying food or overblown flowers. Death is a difficult subject for most of us.

Collishaw's pictures are remarkable in their diversity and composition. They are astonishing because they are often mistaken for paintings. His subjects: the last meals of prisoners on death row. An array of meals are on display. Opulent, trashy, huge, meagre. However, the one that has lived with me since I first saw it at the Manchester Art Gallery as part of The Passion Art Trail,[20] curated by Lesley Sutton, is the glass of wine and the single wafer on a darkened wooden table.[21]

This meal was the choice of a man called Jonathan Nobles, transformed in his twelve years of imprisonment, and ended in his death by lethal injection. He fasted on the day of his execution. In his deep regret at his actions, he asked for forgiveness from each one of his victim's family.

The picture resonated as a tolling bell. It called me to a future I could not see. It reminded me of a Man called Jesus who also took bread and wine before His execution.

There is nothing I can physically take with me on my death. My grubby consumerism, my determined blindness to my selfish choices, the purchasing that bends the backs of unnamed Asians paid a pittance for their tireless efforts. My eco credentials fall in tatters. As if a god I am part of conjuring the wind, the waves, the storm, an ecological doom without heed for my fellow world travellers. These, my true brothers and sisters, my fellows, the ones on whom the quality of my life and theirs depends. Many cry because of that wind, and I do not hear them.

In the Collishaw picture, the wafer speaks of appetite.

For some it is violence and bloodshed. People involved in massacres tell of the inability to stop. They are overcome by a bloodlust and they see nothing other than rape, torture and murder until they are spent. When they return to their right mind, they are horror-struck at their actions.

Others turn to pornography, much of it violent, and we wonder that our children, who manage to gain full access to the most explicit, fail to understand the nature of natural and normal relationships with other human beings.

Substance abuse removes us from the world in which we live, because it is too painful.

Our appetite for money outweighs all others. We will strip, sell, degrade, strut across a carpet of humanity to acquire. Irrelevant, if tomorrow we die.

The person who chose the wafer alone reflected back on a man he loved. A man who spoke words of healing and hope to an ethnic group desperate for release from oppression. This man spoke of a different appetite – an appetite for goodness. He taught by His actions what goodness embodied. His central theme was love: to love God, to love ourselves, to love each other.

The wine in the glass speaks of home. It is a violent image because it represents blood. Blood from the death of a Man from Palestine. The Man who said death could not hold Him. One who travelled through the portal of death and returned. He it is who invites us to follow Him home, where we will be safe and loved.

There is no embellishment on the table. It is rough-hewn, handmade, reminding us of a physical carpenter who worked hard for his family. A man who amassed nothing in His life except love and hate. Most hated Him and wanted Him dead. A hatred the man on death row understood. In Collishaw's death picture, by faith, love beckons.

EXAMEN

Examen is an ancient spiritual discipline practised daily by many as a form of prayerful reflection in order to detect the presence of God and discern His direction for us. If God is real, then He must communicate. Ignatius Loyola spoke of it in his Spiritual Exercises. This is an adaptation:

1. Be still, quieten the mind and become aware of God's presence.

2. Review the day with thankfulness.

3. Identify emotions within; release them to God and receive forgiveness, acceptance and love.

4. Choose one feature of the day and pray from it – it can be helpful to talk out loud.

5. Look to tomorrow and ask.

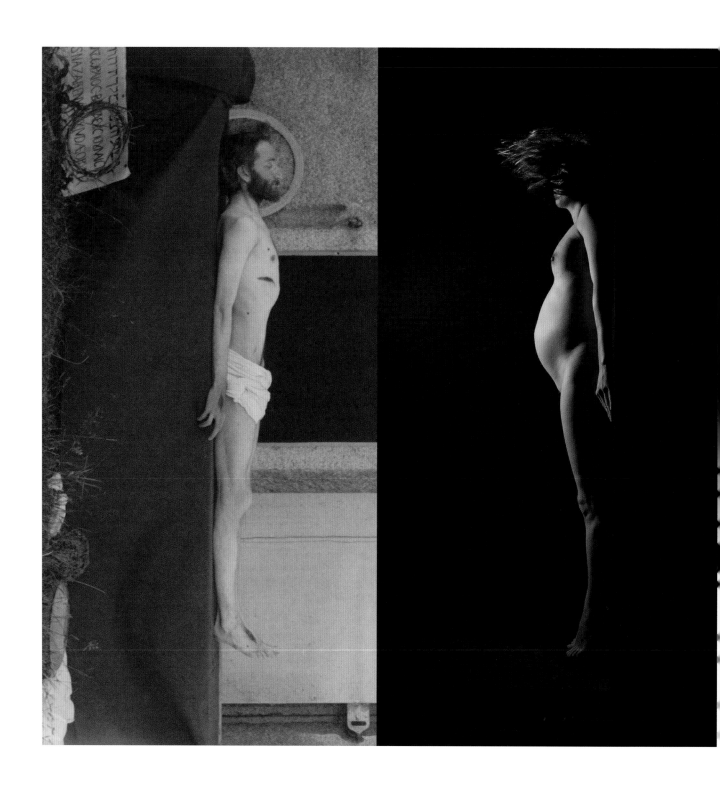

NATAL
Sheona Beaumont
Photographic print mounted on dibond
H:183cm W:183cm
Digital reproduction of Fred Holland Day,
'The Entombment', © Victoria and Albert
Museum, London

This work joins two images separated by more than 100 years of photography. The century-old image on the left is of the photographer himself as the model for Christ. To bridge this gap, it radically re-frames the received image of Western spirituality. It raises a dimension of new life between the figures, with the womb encapsulating regeneration and Spirit.

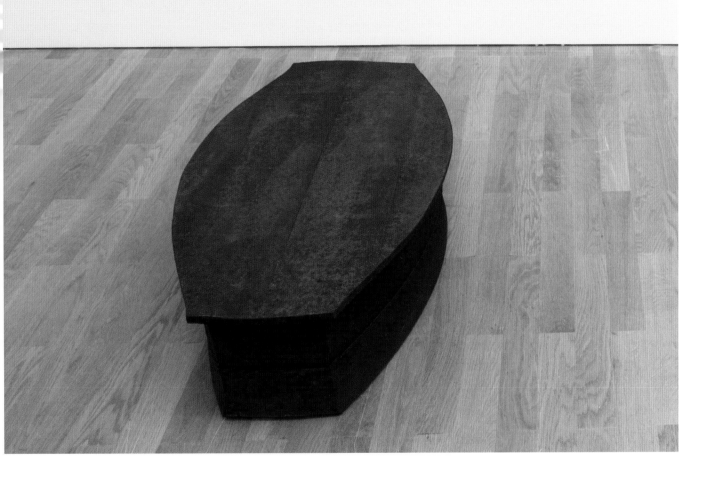

INFANT SARCOPHAGUS II
Julian Stair
Ceramic
H:22cm W:41cm L:78cm

A meditation on death about the mortality of all, this funerary container is reduced to its absolute function. Formed by hand into a rigid and impervious material, it brings death near. Completion requires an individual human body that will enter and exit this physical world.

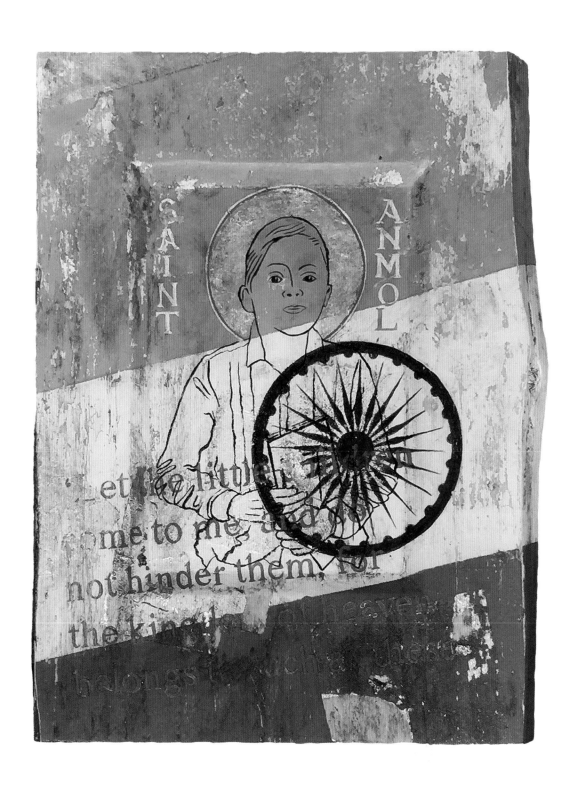

ST ANMOL
Paul Hobbs
Gold leaf and acrylic on wood
H:32cm W:25.5cm D:2cm

A crude icon of a contemporary Indian child martyr is depicted within the weathered national symbols of his country. While explaining the larger context of his life and its background, they remind us also of the uncontrollable forces and violence that nationalist and religious-based exclusion might set in motion.

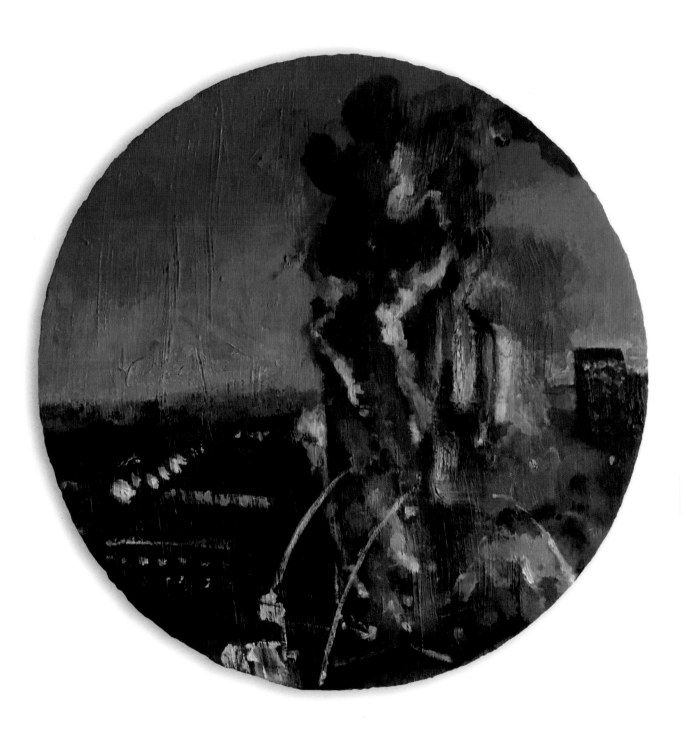

GRENFELL 2017 | A memorial to the Grenfell Tower
Matthew Askey | tragedy of 2017, where God weeps
Oil on wood | with us, witnessing injustice,
D:30cm | indifference and greed.

THE OTHER LAMB
Marjan Wouda
Plaster, aluminium, polystyrene and fabric:
original for bronze
H:20cm W:97cm D:80cm

A newborn lamb, sleeping, or maybe stillborn, is
unsentimentally displayed at twice life-size. The artist's
hand is evident in the use of the materials, emphasising its
fragility. It seems to be stretched out on some kind of altar.
Perhaps it is a sacrifice. If so, to what, and for whom?

THE SUSPENSE OF LIVING ON THE EDGE
ashar
Mixed on wooden panel
H:91cm D:91cm

The artist explores their emotional feelings about a world which seems poised dangerously close to falling into an abyss. Uncertain, we step into the unknown, asking where is God in all our 21st-century chaos?

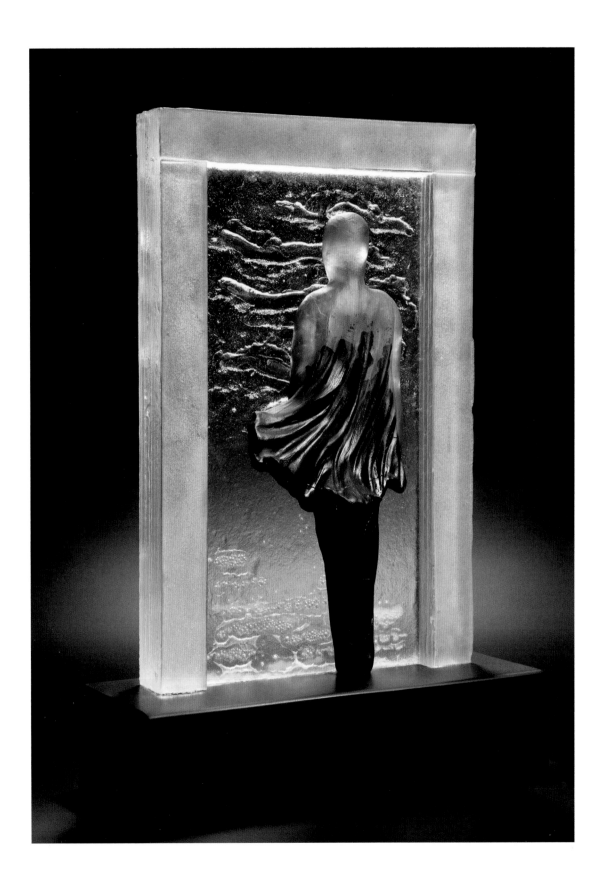

WHERE DO WE GO?
Teresa Chlapowski
Fused and kiln cast glass on slate
H:41cm W:28cm D:11cm

Regardless of our theological or philosophical position, we all die. The question of what comes next, despite our modern, technological world, is perhaps a question of faith. The figure shown here represents us all, standing on the threshold of the unknown.

ETERNAL SINGULARITY

Mark Lloyd

Oil, acrylic, spray paint, marker, enamel, resin, pigment made from ash of burnt artwork and items on canvas
H:180cm W:150cm

What if God Himself can be simulated, that is to say, can be reduced to signs that constitute faith? Then the whole system becomes weightless; it is no longer anything but a gigantic representation of Him.

HERE TODAY GONE TOMORROW

Kate Brett

Paint and print
H:61cm W:32cm per panel

In an increasingly transient society, we have become almost reliant on a fleeting image, a snapshot, to help us remember what we have experienced. Yet if this life is not the end, what will we take with us to the next one?

WEAPON OF MASS DELUSION
Simon Shepherd
Aluminium
H:90cm W:15cm D:15cm

The work represents the way in which God and religion are used to justify the violence and war that are all too common today. The prayer book powers a weapon of war while paradoxically proclaiming the message of peace and love.

NOVA FALLOUT ENLIGHTENMENT DAYS
Leo Santos-Shaw
Mixed media, including embroidery, wood, bone, glitter, cotton
D:45cm

A combination of nuclear bomb test imagery and modern sci-fi gaming reflects the artist's abstract response to current global fears of nuclear catastrophe and ideas of modern-day translations of biblical apocalypse.

EVERYWHERE

EVERYWHERE

Another world – a side-step away;

a wardrobe, a dream, a memory;

the world of quest,

of uncertainty, danger, choice,
courage,

where nothing is as it appears.

A world of transformation –

Love

Self-sacrifice

Wickedness unfrocked

Goodness requited

Of riddles and enchantment,

darkness and light,

confusion and desolation,

laughter and discovery.

Like children we can rediscover
possibility.

Such a plaything can be picked up,
examined, tested, and our unfettered
imagination may leap from the unseen
to seen.

BELIEVERS

As a young woman, my experience of life was difficult. My parents divorced when I was twelve and my mother remarried when I was thirteen. I found myself living with a stepfather who was not interested in the three children of the family he had married into. My mother was torn between a rock and a hard place. I existed in a fog, understanding nothing, deeply hurting, cast adrift on the island of myself.

On returning from my French travels I had a breakdown and was put under the care of a psychoanalyst with whom I met weekly. These were painful and difficult times for a twenty-year-old. I am so thankful to Alan, who taught me how to communicate. As I learnt from him he helped me unlock, and a creative human being began to emerge.

I found faith and a friend and I began to believe I had something to contribute.

I share this because, whoever we are, we need people who will believe us. They give us energy, belief and fresh hope. Alan always believed that one day I would write.

An artist wrote a poignant letter to us regarding this competition. Her art contains the symbols of her faith. Repeatedly, agents told her to remove them, certain that her chances of selling her work would dramatically increase. Gatekeepers are often those with different priorities and decide for others what they may see, read, absorb.

She articulated her thanks that this competition existed. The knowledge of our presence gave her hope about her work, along with fresh energy.

So many artists, because of gatekeepers, believe the lie that their work is valueless. A large pile of rejections can mean the stream of creativity becomes strewn with boulders and, with time, so blocked, it fails to flow. We abandon our calling and channel our gift in different ways, but remain constipated and crushed. Our pain means it becomes an area of life we avoid – a 'No-fly Zone'.

We need to step back in order to step forward, says my friend Maggie Ellis, psychosexual counsellor, founder and CEO of Lifecentre Rape Crisis Service. If we do this, the 'No-fly Zone' we have set up within ourselves will reveal itself. Life moves on, we move on, but we are not the same. Damaged and blocked, freedom has left us.

In life, we get hurt. We all live with pain. Yes, we do. Our stream dries up to a trickle and we wonder why we can't function. Why are we depressed? How did we lose so much? Is there restoration?

Go back. Look at the boulders and carefully begin to remove them. 'How do I do this?' I hear. With someone who will walk the journey with you. Perhaps a counsellor. I am convinced we cannot do life on our own. At different times in my own life I needed professional help, and I asked for it. At other moments, trusted friends were there for me.

What lies in going forward after removing the stones?

Those with faith are always looking for the 'thin' space. This is the space where heaven and earth, the supernatural, the magical, meet; the space where things we cannot explain rationally happen.

This is countercultural. Some believe it does not exist. Many believe it does.

When you look at the art in this book, you find artists working to access that 'thin' space, the magical place where something so much bigger than the physical piece is communicated. It's not allowed in our secular world and is decried and denounced by many voices in the public space. So effective has the shutdown been on the 'thin' space, we have even lost the question, let alone the possibility.

This is about allowing ourselves the freedom to search for and expect 'magic' again. It is about walking into a hidden place and experiencing the feel of a fur coat on our face. As our eyes adjust, the light of a lamp reveals glinting snow. We walk through the wardrobe, our feet crunch, and before us lie stone animals, mysteries, things to explore. Excitement mounts.

The artists featured in this book stepped through a wardrobe, they discovered the snow, heard its crunch underfoot. They invite you to join them.

Spring is coming.

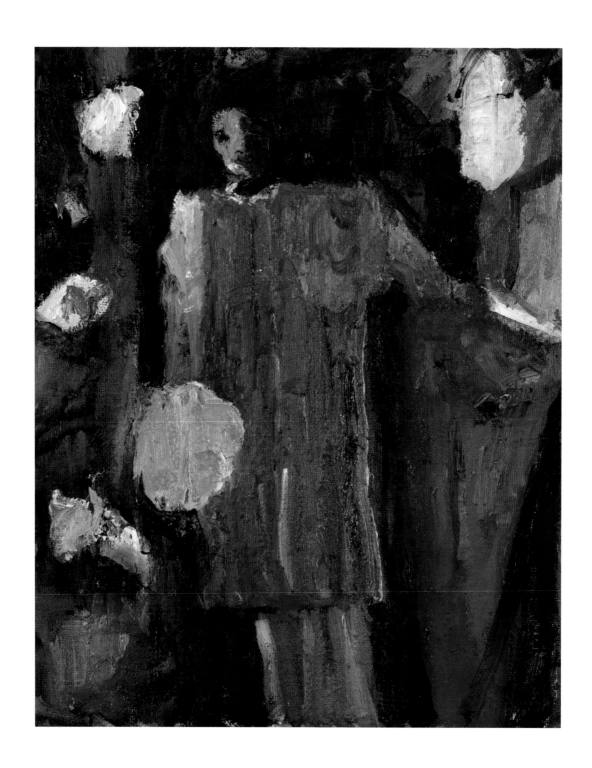

STANDING IN BETWEEN
Simon Klein
Oil on board
H:42cm W:36cm

The standing figure, still, like the angel who asked Joshua to remove his sandals as he stood on holy ground. What is space? The shapes across the picture allegorise the divide of this world and the next.

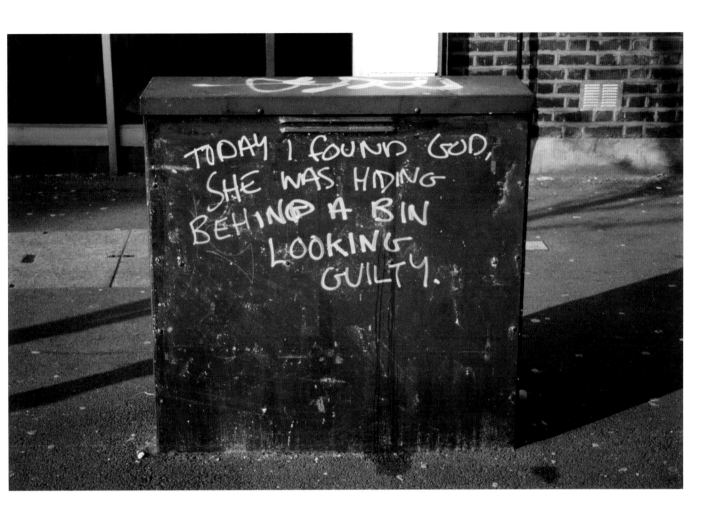

GOD
Trevor Attwood
Photograph
H:30cm W:45.5cm

An unexpected discovery, the photographer found this piece of street graffiti in Hackney. A fleeting, jokey moment, no doubt scrubbed clean later by a council worker, but one that reveals humanity's cynicism towards an apparently absent God in an unjust world.

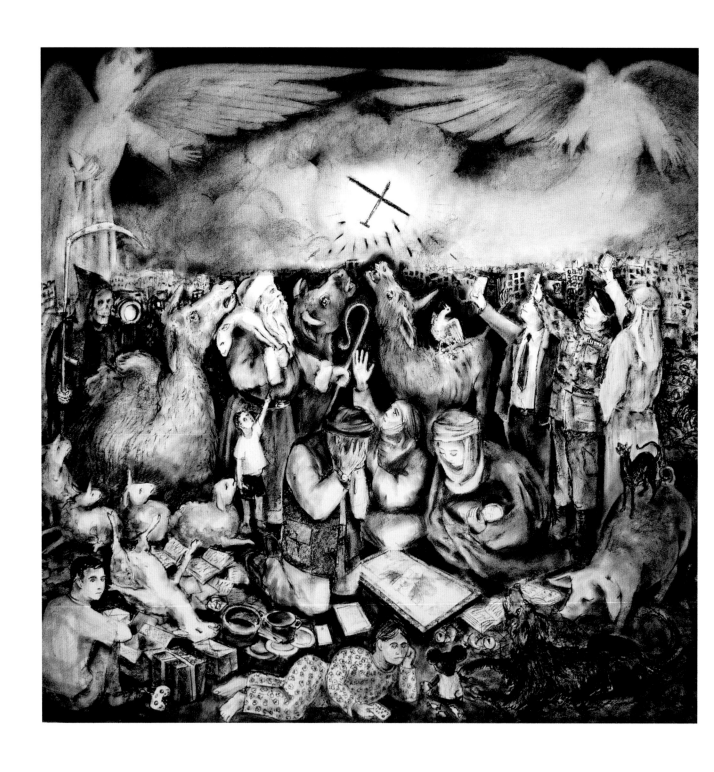

NAIVETY
Peter Codling
Charcoal on paper
H:123cm W:123cm

A single, starkly drawn scene compacts worldly geography, real and imagined events and the planes of existence that encompass them. An apparently simple story splinters into a cacophony of individual happenings we spectate from our television screen. Where? Who? What? Why?

HOW DO YOU SEE ME?
Roz Bradbury
Photograph
H:51.5cm W:76.5cm

A meditation on the experience of living in the unending busyness and loneliness of modern life. Behind each window exists one more soul. So much life, so many possibilities! But there are people living entirely unnoticed by others. God might weep for the lonely, and delight in the creativity of so much humanity.

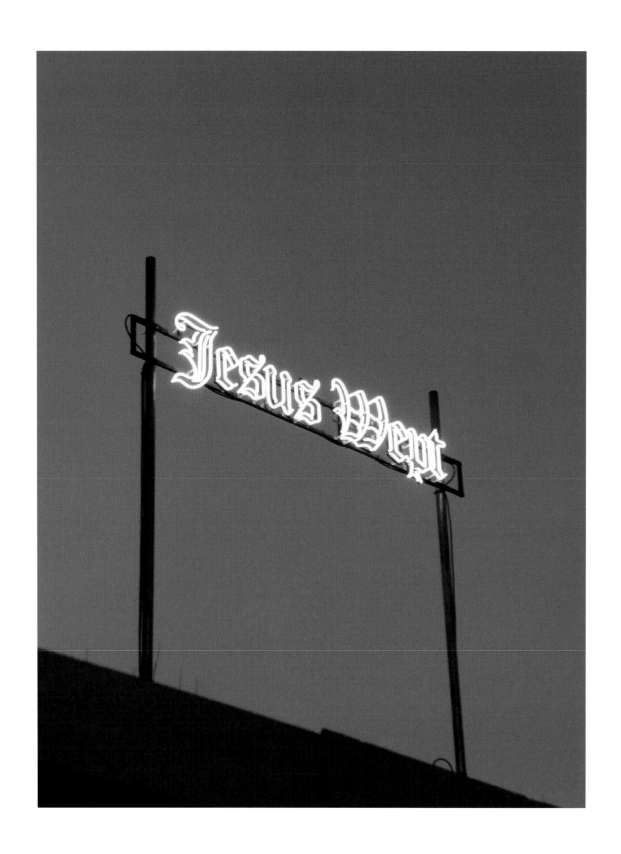

JESUS WEPT | The words refer to human mortality and the fragility of life.
Colin Booth | The artist introduces a contemporary, commonplace and
Neon, stainless steel | functional medium to express a beautiful, succinct and
H:52cm W:220cm D:20cm | profound sentence. It brings the possibility of stillness and
| contemplation into the everyday.

ORGANISED KINDNESS
Bridget Adams
Hand drawn, new media, drawn
back into by hand
H:200cm W:104cm

Inspired by the problems of homelessness in Manchester, this piece expresses the artist's desire for each person to experience freedom and dignity. The lower panel figure represents the heart of humanity fertilising, reinvigorating and triumphing over decay, ignorance, fear and meaninglessness.

IN THE DETAIL
Kate Green
Diptych, Acrylic on canvas
H:51cm W:103cm

In each act of kindness, each spark of inspiration, every expression of forgiveness, in creativity, in nature, in our fingerprint, in the universe – all reveal a God of detail. He is all around, in each moment, waiting for us to see Him in the detail.

INTO THE LAQUEARIA
Alastair Gordon
Oil and acrylic
on birch ply
H:180cm W:240cm

The artist's painting practice explores questions of faith and image-making. Biblical subjects are taken from historical paintings and reinterpreted in a contemporary context. It emulates the multiple platforms by which we mediate and consume images today. Is there a place for the Christian motif in contemporary life?

DUNGENESS
Samuel McGoun
Oil and acrylic on
canvas
H:170cm W:150cm

God the fisherman still looking for people to work with. Every fish is unique. God works alongside the tradespeople, the builders, the artists. He never leaves.

TONDO II | Digital collage technology
Hania Farrell | investigates a web of hidden
Lightbox | symbols to signify different
D:183cm | religions, faith and philosophies
represented within populations
throughout history. Light is
a valuable metaphor as a
metaphysical path of faith
and Enlightenment. The artist
sees commonalities in some
Christian teachings with
Islamic, Buddhist and ancient
polytheistic religions, and
rationalist philosophies.

WHAT MATTERS | A 'slice of the universe' large-
(THE SCATTERING) | scale installation arranged
Claudia Moseley and | according to stages of cosmic
Edward Shuster | evolution. The work reflects on
and-blown glass | the symbols of church stained-
bubbles, steel cabling, | glass windows. Its immersive
projector(s) | experience of sculptural light
painting invites the question,
'What Matters?'

ACKNOWLEDGEMENTS

Book text written by: Ann Clifford

Art compiled by: Katrina Moss and Ann Clifford

Judges: Marcus Lyon, Ghislaine Howard, Laura Gascoigne, Mark Dean, Katrina Moss

Exhibition Curator: Sophie Hacker

Exhibition Installer: Simon Coote

Exhibition texts edited by: Nicholas Morris

Marketing and PR: Lucy Silver, Kate Burke, Helen Farquharson, Peter Cresswell

Submissions: Phil Moss

Book Design: David Salmon

Website & Graphic Design: Micah Purnell

Website Build: James Seddon

Sponsors: Bible Society

WITH THANKS FROM ANN

To all the above for their willingness to go on this high-speed journey.

To Stuart Martindale and to West London Writers.

To Katrina, my teammate in so many adventures. May they never stop.

To Steve, my lovely husband, who often wonders what's going to happen next!

WITH THANKS FROM KATRINA

To all the above for their skills, expertise, time and faith in this project.

To all the artists who entered the Chaiya Art Awards. We really appreciate your participation and sharing with us your imagination and creativity.

To Lesley Sutton, who was the first person to really get behind this idea. Your encouragement and advice was invaluable.

To my friends and family who cheered me on when the going got tough!

To my dear friend Ann, it has been a joy and a privilege to go on this latest adventure with you.

To Phil, my supportive and loving husband, for joining me on the journey.

Lastly, to the most important person in my life, to Whom this book is dedicated, thank You for entrusting me with the vision for these awards. Any good outcomes, the honour all goes to You.

EXHIBITION 29TH MARCH – 8TH APRIL 2018

Sophie Hacker, Curator for Chaiya Art Awards at gallery@oxo, Oxo Tower Wharf

If you have ever visited a church or a cathedral, anywhere in the world, you'll know what it is like to walk through the entrance and come across 'religious art'. It might be in the form of large and impressive paintings or carvings, statues of saints tucked away in niches, richly coloured textiles on an altar frontal, or spectacular frescos or mosaics on the walls and ceilings. All of this art is attempting to do one thing – to speak about God.

It's quite another matter to stroll past a modern gallery on London's South Bank, minding your own business, to find yourself encountering a question at the back of many people's minds: Where is God in our 21st-century world?

People who don't sign up to 'religion' still have a right to ask this big question. What we find in the first Chaiya Art Awards is an extraordinary response from people of many faiths and none. Buddhists, Jews, Muslims, Christians, atheists, agnostics and others have all made a contribution in an amazing variety of ways.

Here we find art that repeats the question back to us: for example, where is God in the refugee crisis? Where is God for the homeless? Where is God in the chaos of the world we live in? But we also find art that offers us an answer – God is in the detail, in beauty, in kindness, in nature, in relationships. God is in the small things as well as the big. For some of the artists, their answer to the question is a simple one: 'God IS.'

Here we find paintings, sculptures, textiles and mosaics, but we haven't had to seek them out in a church or cathedral, a mosque or synagogue. It has come to find us, as we stroll past on our way to work, or sightseeing on a day trip to the capital.

The quality of the work is astounding. As curator, the task of putting together this exhibition has been an awesome one. With more than 450 submissions and a relatively small gallery to work in, it was never going to be possible to include all the work that I would have wanted to show. One or two of the submissions could have filled the entire space! Many excellent pieces ended up on the 'cutting-room floor', entirely owing to the constraints of space. I am certain of one thing: everything included will enrich the conversation, provoke thought and challenge us. Most of all, the work will take us further along the road that asks, 'Where is God in our 21st-century world?'

Sophie Hacker is an artist and educator. She is a trustee of ACE, and artist in residence at Winchester Cathedral.

CITATIONS

1. Hilary Brand and Adrienne Chaplin, *Art and Soul: Signposts for Christians in the Arts* (Solway, 1999), p.175.

2. Hilary Brand and Adrienne Chaplin, *Art and Soul*, p.70.

3. Cited in Vaughan Roberts, *God's Big Design* (IVP ebook, 2005).

4. William Shakespeare, *A Midsummer Night's Dream*, Act 5.1.12-18.

5. Attributed to William Thomas Cummings, US Military Chaplain, 1942.

6. Peter Kreeft: *Heaven: The Heart's Deepest Longing.*

7. Be Still: Passion Art Trail 10th February – 2nd April 2016. Available at www.passionart.guide (accessed 22nd February 2018).

8. Isaiah 61:3 (NIV).

9. Dallas Willard Center for Spiritual Formation, Facebook, 20th April 2016.

10. Richard Rohr, cited in a personal conversation.

11. W H Yeats, quoted in *The Week* 'Quotes', 3rd February 2018, p. 23.

12. See Matthew 7:7.

13. Matthew 6:21 (*The Message*).

14. Matthew 4:1-11.

15. Ezekiel 37:3.

16. David Foster Wallace, 'This is Water: Some Thoughts, Delivered on a Significant Occasion, about Living a Compassionate Life'. Available at www.goodreads.com. His great speech, 'This is Water: Commencement Speech to Kenyon College Class of 2005', is available on YouTube https://www.youtube.com/watch?v=8CrOL-ydFMI (accessed 19th February 2018).

17. Henri Nouwen, 'What Is Most Personal Is Most Universal', 23rd February. Available at http://henrinouwen.org/meditation/what-is-most-personal-is-most-universal/ (accessed 19th February 2018).

18. Tej Sidhu, Poet, Used with permission.

19. Dietrich Bonhoeffer, *Wonder of Wonders: Christmas with Dietrich Bonhoeffer* (out of print).

20. Passion Art | Be Still 2016. Available at www.passionart.guide (accessed 19th February 2018).

21. Mat Collishaw, 'Jonathan Nobles'. Available at https://matcollishaw.com/works/last-meal-on-death-row-texas/ (accessed 19th February 2018).

INDEX OF COLOUR PLATES

The views and opinions expressed in this work do not necessarily reflect the views and opinions of the artists, but that of the publisher, the author and the the organisers of the Chaiya Art Awards.